KB208107

"Chicken or the Egg." *Wikipedia*, 2022. wikipedia.org/wiki/
Chicken_or_the_egg.

뭐가 먼저냐
— 형식이 먼저냐, 내용이 먼저냐

정대봉

WHICH CAME FIRST
— FORM OR THE CONTENT

DAEBONG JEONG

프레스 프레스

PRESS PRESS

뭐가 먼저냐
— 형식이 먼저냐, 내용이 먼저냐

WHICH CAME FIRST
— FORM OR THE CONTENT

디자인	정대봉
지은이	정대봉
영문 번역	윤상영, 타냐 베어
영문 교열	송무늬
제작	인타임
도움	석재원

Design	Daebong Jeong
Author	Daebong Jeong
Translation	Sanyeong Yoon, Tawnya Baer
Copyediting	Munee Song
Printing & Binding	Intime
Thanks to	Jaewon Seok

발행처	프레스 프레스
1쇄 발행일	2022년 12월 5일
2쇄 발행일	2023년 6월 14일

Published by PRESS PRESS
1st on December 5, 2022
2nd on June 14, 2023

프레스 프레스 PRESS PRESS
03413 서울시 은평구 연서로9길 20-5 301호
instagram.com/presspress.id
presspress.id@gmail.com

ISBN 979-11-980935-0-9 13650
Copyright 2022. PRESS PRESS All rights reserved.

아이디어가 반드시 논리적인 순서대로 진행되는 것은 아니다. 그것들은 무언가를 예기치 않은 방향으로 둘 수도 있지만, 다음 생각이 떠오르기 전에 반드시 마음속에서 완성되어야 한다.
— 솔 르윗

Ideas do not necessarily proceed in logical order. They may set one off in unexpected directions, but an idea must necessarily be completed in the mind before the next one is formed.
— Sol LeWitt

Content precedes form. This seems like a self-evident fact, especially when it comes to making a book. The reason is that authors or publishers often require designers to design as a container for writing, that is, a form tailored to the contents. It goes beyond merely design. The former and latter relationships are set in stone and occasionally mistaken for hierarchical ones. There can, however, be no hierarchy between form and content because the form is what causes the content to exist in the first place. The opposite is also true. Granted, that does not mean there can be any order. It is for the same reason why we are unable to respond to the question *Which came first: the chicken or the egg?*. Whichever comes first, form gives birth to content, and content gives birth to form. By reversing the conventional relationship of ordering between form and content, "WHICH CAME FIRST" demonstrates that superiority and inferiority, as well as former and latter, can never exist between the two.

FORM OR THE CONTENT

내용은 형식에 앞서 존재한다. 이는 특히 책을 제작할 때에 자못
자명한 사실처럼 여겨진다. 저자 혹은 출판사는 디자이너에게 글을
담는 그릇으로써 디자인을, 그러니까 내용에 맞춘 형식을 흔히
요구하기 때문이다. 비단 디자인에 국한된 것도 아니다. 선후 관계는
고착되어 이따금 위계 관계로 오인된다. 그러나 형식과 내용에 위계가
존재할 수 없음은 분명하다. 내용을 내용으로 존재하게 하는 것은 다름
아닌 형식이기 때문이다. 그 반대도 마찬가지이다. 그렇다고 해서
순서가 존재할 수 있는 것도 아니다. 닭이 먼저냐, 달걀이 먼저냐하는
물음에 답할 수 없는 것과 같은 이유에서다. 무엇이 먼저였든 형식은
내용을 낳고, 내용은 형식을 낳는다.『뭐가 먼저냐』는 형식과 내용의
관습적 선후 관계를 뒤바꿈으로써, 둘 사이에 먼저와 나중은 물론 우와
열은 결코 존재할 수 없음을 증명한다.

형식이 먼저냐, 내용이 먼저냐

The titles of books, writings, and exhibitions are written in quotation marks. Quotes are written in italic instead of using quotation marks.

외국어 고유명사 표기는 국립국어원의 외래어 표기법을 참고해
표기했다. 단행본은 겹낫표(『』)로, 단행본 내의 글은 낫표(「」)로,
전시명은 겹화살괄호(《》)로 묶었다. 인용문은 따옴표를 사용하는
대신, 명조체로 표기했다.

Creating a page arrangement table, I guess the order of "WHICH CAME FIRST." This book starts with an index, which usally decorates end of the book. The references are right there after the index is complete. Starting with the divisional title page, the body text comes, and somewhere in the middle of the body text, full figures' signature is located. Only after the body text is finished, the table of contents, explanatory notes, preface, dedication, copyright paper, title page, and head picture appear in order, and other additional elements are deleted. The head that comes after the body text openly asks, "Which came first?" In other words, "WHICH CAME FIRST" means that either of them can come first.

쪽 배열표를 작성하며 『뭐가 먼저냐』의 차례를 가늠해 본다. 통상 책의 마지막을 장식하는 찾아보기를 책의 시작으로 정한다. 찾아보기가 끝나면 곧장 참고 문헌이 자리한다. 첫 번째 중간 표제지(도비라)를 시작으로 본문이 오고, 본문의 중간 어딘가에 꽉 찬 도판 한 대수가 위치한다. 본문이 끝나고서야 차례, 일러두기, 머리말, 바치는 글, 판권지(간기), 속표지, 머릿그림이 차례로 등장하고, 이외의 부가 요소는 삭제한다. 버젓이 본문 뒤에 오는 머리는 "뭐가 먼저냐"고 묻는다. 다시 말해 "뭐가 먼저냐"는 뭐든 먼저일 수 있다는 말이다.

(20) PAGE ARRANGEMENT In the composition of a universal book, *things that go before the body text* include half title page, frontispiece, main title page, imprint page (copyright), dedication, corrigenda, preface, acknowledgments, explanatory notes, table of contents, illustrations, and the list of abbreviations. The *things that go behind the text* include reviews, appendix, chronology, endnotes, glossary, bibliography, author and author introductions, drawing credits, and index.(20) However, since this book has already deviated from the universal composition, the book escapes from it without regret.

(20) Editorial Department of Open Books, "Composition of Books," *Open Books Editing Manual* 2022 (Paju: Open Books, 2022), 319–320.

⑳ 쪽배열 보편적인 단행본의 구성에서 본문 앞에 들어가는
 것들에는 반표제지, 머릿그림, 속표지, 판권지,
바치는 글, 고침표, 머리말, 감사글, 일러두기, 차례, 그림 차례,
약어표가 있고 본문 뒤에 들어가는 것들에는 후기, 부록, 연보, 후주,
용어 풀이, 참고 문헌, 작가 및 필자 소개, 도판 크레디트, 찾아보기가
있다.⑳ 그러나 본 책은 이미 보편적인 구성을 벗어날 대로 벗어났기에,
그것에서 미련 없이 탈피한다.

⑳ 열린책들 편집부, 「책의 구성」, 『열린책들 편집 매뉴얼 2022』(파주: 열린책들, 2022), 319–320.

⑲ REFERENCES Coincidence or not, each writing has one reference. *Just as we usually understand the world through an artist's work, sometimes we can understand someone's work through the world. For one to understand the work of the artists, it takes being absorbed in their universe, just like in the general sense that one understands the world through the artist's work*. However, a language that *stands in an objective manner in that it borrowed the language from books that have already been published* but has flowed into a new context objectivity is bound to be blurred. *In the vast world of books, some sentences exquisitely fit as if they were written to describe the work of … while others interpenetrate all the works but express nothing in the end.*⑲ The formal structure that pursues perfection has completeness in itself, but when the form is connected with the content, the impression is multiplied.

⑲ Minjung Kim, "Kiljong Arcade and 18 Books," *Porcelain Berry* (Seoul: Hwawon, 2022), 70.

⑲ 참고문헌 우연인 듯 아닌 듯, 하나의 글 뭉치는 하나의
참고 문헌을 갖는다. 보통 우리가 예술가의
작품을 통해 세계를 이해하는 것처럼, 때론 세계를 통해 누군가의 작품을
이해할 수도 있다. 그러나 이미 출판된 책에서 그 언어를 빌려왔다는
점에선 객관적으로 존재하지만 새로운 맥락으로 흘러간 언어는,
객관성이 흐려지기 마련이다. 책이라는 광대한 세계 속, 몇몇 문장은
마치 해당 작업을 설명하기 위해 쓰인 것처럼 절묘하게 들어맞는가
하면, 어떤 문장은 … 모든 작업을 관통하는 동시에 아무것도 의미하지
않는다.⓳ 완벽을 표방한 형식적 구조는 그 자체로 완결성을 갖지만,
형식이 내용과 결부할 때 감동은 배가한다.

⓳ 김민정,「길종상가와
18권의 책들」,『사포도』
(서울: 화원, 2022), 70.

It is reset in order to discover a fresh order for the information with the intention of preventing the emphasis from becoming focused on a certain person or concept. Items appear in the text, but are selected with great care, as those that seem somewhat unrelated to the text. By re-appearing words that deviated from the mainstream message of the text, the non-mainstream is proudly entering the mainstream.

특정한 인명이나 개념어에 중요도가 쏠리는 것을 방지하고자, 내용에 새로운 질서를 부여하는 것을 찾아보기의 목적으로 재설정한다. 항목은, 본문에 등장하지만 본문과 다소간 관계없어 보이는 것으로 심혈을 기울여 선정한다. 본문의 주류 메시지를 빗나간 단어를 다시금 등장시킴으로써, 비주류는 주류로 당당히 들어선다.

Writer and editor Nuiyeon Kim's collection of poems called "The Grid Eraser", provides a thick search of almost 30 pages. (Although thickness is not proportional to kindness) The fragments of text rearranged in word segments function as *an analysis tool navigation tool the content of another point* spotlight that important things to everyone. *rather than a* and *a way to see the work from of view.*⑱ The only shines on the is distributed fairly

⑱ Johanna Drucker, "Diagrammatic Writing," Translated by Sulki Choi, (Seoul: Workroom Specter, 2019), 30.

작가이자 편집자인 김뉘연의 시집『모눈 지우개』는 거진 서른 쪽에 달하는 두툼한 찾아보기를 제공한다. (두툼함은 친절함과 비례하진 않지만) 어절 단위로 나뉘어 재배치된 글의 조각은 내비게이션보다는

분석 도구로써, 또 다른 관점에서 기능한다. 중요한 스포트라이트를 모두에게 공평히

❶⑧ 조해나 드러커, 『다이어그램처럼 글쓰기』, 최슬기 역, (서울: 작업실유령, 2019), 30.

작업의 내용을 보는 방법❶⑧으로 것에만 비치던 책을 지탱하는 배분한 것이다.

⑱ INDEX The glossary provided at the end of the book
 in the name of index refers to a list in a certain
order so that important words or phrases in the content can be
easily found. The multi-column searching page, which is typeset
without gaps, makes you realize the inherent power of the list.
Index, on the other hand, is undeniably a sign that power has
been at work because it makes a distinction between what is
significant and what is not.

⑱　　찾아보기　　책의 말미에서 찾아보기라는 이름으로 제공되는
　　　　　　　　　　　용어 색인은, 내용 중 중요한 낱말이나 구절
따위를 쉽게 찾아볼 수 있도록 일정한 순서로 나열한 목록을 가리킨다.
다단으로 빈틈 없이 조판된 찾아보기 페이지는 목록 본연의 힘을
실감케 한다. 한편 찾아보기는 여지없이 중요한 것과 중요하지 않은
것을 구분하기 때문에, 권력이 작용했다는 확실한 흔적이다.

Quotations that have different characteristics from other texts are fragmented and barely hold their breath, and their unity with the original text is in a precarious situation. As a tribute to the original text (almost) written in the Myeongjo font, Source Han Serif, a Myeongjo typeface, is used only for citations. Source Han Serif, made by Google and Adobe, provides Semibold with a thickness similar to Jibaek Regular. The use of Gothic and Myeongjo fonts together eliminates the abuse of unnecessary double quotation marks. English is written in Neue Haas Unica (Regular, Bold), which is similar shape to Jibaek, and quotation marks are treated in italics.

여타 본문과 다른 성격을 보유하고 있는 인용문은, 조각난 채 겨우 숨을 유지하며 그 원문과 결속이 위태로운 상황에 있다. (십중팔구) 명조체로 쓰인 원문을 향한 헌사의 뜻을 담아, 인용문에 한해서는 본명조를 사용한다. 구글과 어도비의 합작인 본명조는 지백 Regular와 그나마 흡사한 굵기의 Semibold을 제공하고 있다. 고딕체와 명조체를 혼용함으로써 불필요한 큰따옴표의 남용도 사라진다. 영문은 지백과 엇비슷한 형태인 Neue Haas Unica (Regular, Bold)로 하여 섞어 짜고, 인용문은 이탤릭으로 처리한다.

Standing at the opposite point of a custom, the basic Korean font is Jibaek, a Gothic font, which means Korean san-serif typeface. Jibaek, created by font designer Jinhyeon Park, is a type family for body text based on Bojinjae Gothic, which was drawn by Jeongho Choi. The font with a calm and neutral impression is wider horizontally than other Gothic fonts, so it goes well with ample space between letters. It proudly proves that typefaces that silently performed their duties in "old-fashioned" media are still effective in new media.[17] It is also unusual type family as to name each 120g, 260g, and 400g, and through the name suggesting the basis weight of the paper, you can guess what environment the designer drew the letters with in mind. Correspondingly, 120g, similar to the basis weight of inner paper, is used for the body and 260g, similar to the basis weight of the cover, is used for the display.

[17] Eric Spiekerman, "Choosing Type," *Typography Essay*, Translated by Jooseong Kim, Yongshin Lee, (Paju: Ahn Graphics, 2014), 75.

관행의 대척점에 서서 기본 한글 서체는, 고딕 계열 서체인 지백으로 한다. 서체 디자이너 박진현이 만든 지백은 최정호가 그린 보진재 고딕을 본으로 삼은 본문용 활자 가족이다. 무덤덤하고 중립적인 인상의 서체는, 다른 민부리 서체에 비해 넉넉한 자간과 잘 어우러진다. '구식' 임무를 수행하던 매체에서 묵묵히 글자체들이 새로운 매체에서도 여전히 효과적[17]이라는 사실을 보란 듯 입증한다. 각 활자 가족의 이름을 120g, 260g, 400g이라 칭하는 것도 특이한데, 종이의 평량을 암시하는 이름을 통해 디자이너가 어떤 환경을 염두에 두고 글자를 그렸는지 추측할 수 있다. 이에 대응하여 내지 평량과 유사한 120g을 본문용으로, 표지 평량과 유사한 260g을 제목용으로 작업한다.

[17] 에릭 슈피커만, 「활자 고르기」, 『타이포그래피 에세이』, 김주성, 이용신 역, (파주: 안그라픽스, 2014), 75.

⑰ FONTS (Although it is getting better) In the established publishing market, the text used in Myeongjo, which means Korean serif typeface, is regarded as an im-mutable truth. In fact, the publishers, Open Books, set the Korean font of the text to SM3 Shinmyeongjo. (Some "art books" are excluded here.) The behavior of following customs with a naïve attitude that what is familiar is good hinders the diversity of the market.

⑰ 서체 (나아지고 있긴 해도) 기성 출판시장에서 명조체로 쓰이는 본문은 불변의 진리처럼 여겨진다. 실제로 출판사 열린책들은 본문의 한글 서체를 SM3신명조로 못 박아두기도 했다. (여기에서 일부 '예술서'는 제외된다.) 익숙한 게 좋은 거라는 나이브한 태도로 관행을 답습하는 행태는 시장의 다양성을 저해한다.

Moving on from the part where it says, *The footnotes seemed to be an obvious choice for creating a subtext,*[16] footnotes

[16] Michalis Pichler, "Art Book Fair as Public Spheres," *Publishing Publishing Manifestos*, Translated by Gyeongyong Lim, (Seoul: Mediabus, 2019), 39.

now exercise equal value to the main text. It doesn't have to go underneath the text anymore. Footnotes of the same font size as the body text can be placed anywhere above, below, inside, or outside the body text, and the hierarchy that has been established so far becomes much flatter.

각주는 서브텍스트를 만들기 위한 명백한 선택❶⑥에서 나아가, 이제는

❶⑥ 미할리스 피힐러, 「공론장으로서 아트북페어」, 『출판선언문 출판하기』, 임경용 역, (서울: 미디어버스, 2019), 39.

본문과 동등한 가치를 행사한다. 더 이상 본문의 아래에 깔려있을 필요가 없다. 본문과 같은 폰트 사이즈의 각주는 본문의 위, 아래, 안, 바깥 어디든 자리할 수 있으며, 지금껏 굳혀진 위계는 한결 평평해진다.

⑯ FOOTNOTES "Pre-theoretical Assumptions in Evolutionary Explanations of Female Sexuality," designed by graphic design studio PRESS ROOM, attempted to subvert the hierarchy of footnotes and text. Footnotes are placed in place of the original text, and the form of wrapping the book with dense text hidden in a coverlet (jacket) throws an unconventional question to the structure that is taken for granted. Graphic designer Hezin O gave separate flow to the footnotes and main text in "Writing about Writing 16 Pages." By forming an independent narrative, the footnotes, which were merely subordinate to the main text, were recognized for their independent readership.

⑯ 각주 그래픽 디자인 스튜디오 프레스룸이 디자인한
 『여성 섹슈얼리티에 대한 진화론적 설명에 담긴
전前이론적 가정』은, 각주와 본문의 위계를 전복시키는 시도를 보였다.
기존의 본문 자리에 각주가 위치하고, 덧싸개(재킷)에 숨겨진 빽빽한
본문이 책을 싸는 형태는, 당연시되는 구조에 파격적인 물음을 던진다.
그래픽 디자이너 오혜진은「16페이지 글쓰기에 관해 글쓰기」에서
각주와 본문에 개별적인 흐름을 부여하기도 했다. 그저 본문에
종속하던 각주가 독립적인 서사를 형성함으로써, 각주는 그제야
자주적인 독자권을 인정받았다.

Considering that you'll be holding the book and reading it, you need enough space so your thumb won't get in the way of the text. 20 mm, the top, bottom, left, and right margin values specified by default in InDesign, seem to be somewhat wide. So I edited margin as 15.6mm, which is the thumb width of nail tips sold by famous nail brands. It may enable us to experience comfortable reading. However, because the center of gravity is biased to the left in unjustified writing, the margins inside the left page and outside the right page are set to 15 mm, which is 0.6 mm narrower than 15.6 mm, by optical adjustment. The font size should be the value that appears when the entire text flows on the pages, and the number of pages specified in the previous section appears. In order to neutralize the hierarchy between elements at least within the page, title of the body text, footnotes, running heads, and page numbers are all unified with the set values of the body text.

책을 들고 읽을 것을 고려하면, 엄지손가락이 본문을 방해하지 않을 정도의 여백이 필요하다. 그러나 인디자인에서 기본으로 지정해 주는 상하좌우 여백 값, 20mm는 넓은 감이 없지 않다. 모 네일 브랜드에서 판매하는 네일 팁의 엄지 넓이, 15.6mm를 여백으로 주고 쾌적한 독서를 바라본다. 다만 왼쪽 맞춘 글에서 무게 중심이 왼쪽으로 치우치는 탓에, 시각 보정하여 좌수의 안쪽과 우수의 바깥쪽 여백은 15.6mm보다 0.6mm 좁은 15mm로 한다. 폰트 크기는 텍스트 전체를 페이지에 흘렸을 때, 앞에서 정한 면수가 나오는 값으로 한다. 최소 페이지 내에서는 요소 간의 위계를 무력화하고자 본문의 제목과 각주, 면주, 쪽 번호(하시라)를 모두 본문의 설정값과 통일한다.

TYPESETTING

First of all, the body text is typeset unjustified. The most frequent argument between designers and publishers is whether unjustified or justified. And the two-end fit always wins with familiarity as a weapon. No matter how familiar a justified writing is, it is true that the space between letters and words is irregular. Japanese and Chinese texts using Chinese characters, hiragana, and katakana do not have spaces, and English texts using Roman characters have hyphens, so using justified writing is not so disastrous. However, a Korean text with a justified format is truly hopeless. On the other hand, text that is unjustified not only maintains the same letter spacing, but also prevents lines from being cut off in unexpected places, and provides something good to look at with different text shapes for each page. Of course, a disaster occurs with only one word left in the last line even in texts that are unjustified, and in such a case, *changing the text to get a better-looking line break*⑮ is actively allowed. It is a positive function when the author and the designer are the same.

⑮ Seong-min Choi, "Material: Language」," *Material: Language* (Seoul: Workroom Specter, 2020), 31.

⑮　　조판　　　일단 본문 텍스트는 왼끝 맞추기로 조판한다. '왼끝 맞추기냐, 양끝 맞추기냐'는 디자이너와 출판사가 가장 빈번히 언쟁하는 사안이다. 그리고 언제나 양끝 맞춤이 익숙함을 무기로 승리한다. 양끝 맞춘 글이 아무리 익숙하다 하더라도 글자 간, 단어 간의 공간이 사실이다. 한자와 사용하는 일문·중문에는 로마자를 사용하는 있어 양끝 맞춘 글이 그러나 양끝 맞춘 국문은 왼끝 맞춘 글은 동일한 뿐만 아니라 행이 엉뚱한

⑮
최성민,
「재료: 언어」,
『재료: 언어』(서울:
작업실유령,
2020),
31.

불규칙한 것은 히라가나, 가타카나를 띄어쓰기가 없고, 영문에는 하이픈이 그리 처참하지는 않다. 실로 절망적이다. 반면 글자 간격을 유지할 곳에서 끊어지는 것을

방지하고, 페이지마다 다른 글의 모양새로 눈요기를 제공한다. 물론 왼끝 맞춘 글에서도 마지막 행에 한 단어만 남는 재앙이 발생하는데, 그럴 때에는 행을 보기 좋게 넘기려고 원고를 고치⑮는 것을 적극적으로 허용한다. 저자와 디자이너가 동일할 때의 순기능이다.

It overturns this implicit rule that no one has enforced. It is like that the book title, author, and publisher are written on the back cover of the book, and the barcode and ISBN are put on the front cover. However, it is clearly expected that readers and bookstore staff will experience inconvenience, so the title is printed with transparent debossing on the front cover to compromise the design.

누구도 강제하지 않은 이 암묵적 규칙을 뒤집는다. 책의 뒤표지에 책 제목, 저자, 출판사를 기입하고 앞표지에는 바코드와 ISBN을 넣는 식이다. 그러나 독자와 서점 직원이 불편을 겪을 게 뻔히 예상되어, 앞표지에 투명한 공박으로 제목을 찍어 디자인을 절충한다.

⑭ COVERS **⑭** National Museum of Modern and Contemporary Art, Korea, *National Museum of Modern and Contemporary Art, Korea Publication Guidelines* (Seoul: National Museum of Modern and Contemporary Art, Korea, 2020), front cover – back cover.

Often, the front cover of a book *includes the title of the book, the name of the author or editor, and the logo of the publisher.* On the back cover, *Print the barcode, ISBN, sale status and price required for book distribution, or make and attach a sticker for materials that are difficult to print. Sometimes a short text that implies or introduces the contents of the book is put in.***⑭**

⑭　　　　표지　　　　❶⓭ 국립현대미술관,『국립현대미술관 출판 지침』
(서울: 국립현대미술관, 2020), 앞표지–뒤표지.

흔히 책의 앞표지에는 책 제목, 저자 혹은 편저자의 이름, 출판사 로고
등을 넣고, 뒤표지에는 도서 유통에 필요한 바코드와 ISBN, 판매 여부
및 가격을 인쇄하거나 인쇄가 어려운 재질의 경우 스티커로 제작해
부착한다. 책의 내용을 함축하거나 소개하는 짧은 글을 넣기도 한다.⓭

Additionally, you need to select 5 additional symbols, which is a symbol system added by ISBN, ISSN, ISNI Korea Center to help understand the nature of publications. The additional code consists of a total of 5 digits by adding the reader target code, publication type code, and content classification code. Since this book is not a friendly liberal arts book that easily interprets professional contents, it is judged that the content is practical, and the reader target symbol is selected as 1. The publication type symbol is set to 3, corresponding to a book, according to the size of a book that is 18 cm or longer in height. Unfortunately, 260, 610, or 970, which are blank in the content classification symbol, cannot be selected, so 650, which includes 'design,' seems to be the best.

추가로 부가기호 5자리를 선택해야 하는데, 이는 한국서지표준-센터에서 출판물 성격의 이해를 돕기 위해 부가한 기호 체계다. 부가기호는 독자대상기호, 발행형태기호, 내용분류기호가 더해져 모두 5자리로 구성된다. 이 책이 전문적인 내용을 쉽게 풀어쓴 친절한 교양 도서는 딱히 아니기에, 실용을 내용으로 한다 판단하여 독자대상기호는 1로 선택한다. 발행형태기호는 세로 18cm 이상인 책의 판형에 따라, 단행본에 해당하는 3으로 한다. 아쉽게도 내용분류기호에 빈칸인 260이나 610, 970은 선택 불가능하여, '디자인'을 포함하는 650이 최선인 듯하다.

While I am restricted, I will strictly abide by the system. An ISBN consists of a prefix element, the registration group element, the registrant element, the publication element, and a check digit, all of which are 13 digits. The prefix element is automatically assigned 979 as 978 was exhausted in 2013. If the prefix element is 979, publications in Korea receive the registration group element 11. The registrant elements are issued by national institutions (ISBN, ISSN, ISNI Korea Center, National Library of Korea), and the number of digits is different for each publisher. Press Press is 980935. The signature identification number that follows is the only one among which the publisher can voluntarily designate it. It is mainly determined deliberately according to the publisher's classification system, but in the case of Press Press, since there is no particular plan, the first number, 0 is used. Finally, the checkmark is calculated by a series of systems to 9.

이왕 구속되는 김에, 그 제도를 철저하게 준수한다. ISBN은 접두부, 국별번호, 발행자번호, 서명식별번호, 체크기호로 구성되며, 모두 합쳐 13자리 숫자로 되어 있다. 접두부는 2013년에 978이 소진됨으로써 자동적으로 979를 배정받는다. 접두부가 979인 경우, 한국의 출판물은 국별번호 11을 받는다. 발행자번호는 국가별 기관(한국은 국립중앙도서관 한국서지표준센터)에서 발행하며 출판사 별로 자릿수가 상이한데, 프레스 프레스는 980935이다. 이어지는 서명식별번호는 이중 유일하게 출판사에서 자율적으로 지정할 수 있다. 주로 출판사의 분류 체계에 따라 계획적으로 정하나, 프레스 프레스의 경우 별 계획이 없는 관계로 가능한 첫 번째 숫자인 0으로 한다. 마지막으로 체크기호는 일련의 시스템에 의해 계산되어 9가 되었다.

⑬ ISBN An ISBN is an internationally recognized unique number for identifying publications. It strongly reflects *a deliberate choice not to leave anything out* and *It is a form of continuity that lends a kind of rhythm and regularity.*❸ Although some criticize it as redemption.

❸ Kyung-yong Lim, "Everything Has Its Own Numbers," *Roma 1-272* (Seoul: Mediabus, Amsterdam: Roma Publications, 2016), 20.

⑬　　　ISBN　　　ISBN은 국제적으로 통용되는, 출판물 식별을 위한 고유 번호이다. 그 어떤 작품도 배제하지 않겠다는 의도를 강하게 반영하며, 이러한 연속성은 일종의 리듬과 규칙성을 부여한다.⑬ 혹자는 그것을 구속이라며 통렬하게 비판하기도 하지만 말이다.

⑬ 임경용, 「모든 것에는 자신만의 숫자가 있다」,『Roma 1-272』 (서울: 미디어버스, 암스테르담: 로마 퍼블리케이션스, 2016), 20.

I start a publishing house under the name "Press Press." "Press Press" shares the naming method with Swiss designer Julia Born, who titled her show "Title of the Show" and Korean graphic design studio and publisher Workroom, who named themselves Workroom. This is also reminiscent of "Report\ Report," a cultural magazine created by graphic designer Sangsoo Ahn, from which it may have inherited *the power of practice against custom with all his might.*[12] After confirming that no place had preoccupied the name, requested documents were submitted to the district office.

[12] Byungjo Kim, "Unfamiliar and Familiar *Report\ Report*," *Letter Seed 15: Sangsoo An* (Paju: Ahn Graphics, 2017), 42.

'프레스 프레스'라는 이름으로 출판사를 시작한다. 프레스 프레스 즉, '출판사 출판사'는 스위스 디자이너 율리아 보른이 자신의 전시 제목을 《전시 제목》이라 짓고, 한국의 그래픽 디자인 스튜디오 겸 출판사 워크룸이 자신들의 이름을 워크룸(작업실)이라 지은 것과 방법을 공유한다. 이는 그래픽 디자이너 안상수가 만든 문화

❷ 김병조, 「낯설고 익숙한 《보고서\보고서》」, 『글짜씨 15 : 안상수』 (파주: 안그라픽스, 2017), 42.

잡지『보고서\보고서』도 연상케 하는데, 그로부터 온 힘을 다해 관습에 대항하는 실천력❷을 이어받았을지도 모른다. 이름을 선점한 곳이 없음을 확인한 후, 요구하는 서류를 관할 구청에 제출했다.

⑫ PUBLISHER To obtain an ISBN (International Standard Book Number), publisher registration is required. Although I have published several publications so far, there are many reasons why I have delayed registering as a publisher and insisted on independent publications. However, what is clear is that the biggest reason was the desire to postpone naming the publisher.

⑫ 출판사 ISBN(국제 표준 도서 번호)을 발급받기 위해서는
 출판사 등록이 필요하다. 지금껏 출판물을 몇 차례
발행해왔음에도, 여태 출판사 등록을 미루고 독립출판물을 고집했던
이유에는 여러 가지가 있다. 그러나 분명한 것은 출판사 이름을 정하는
것을 유보하고 싶은 마음이 가장 큰 이유였다는 것이다.

⑪　PRODUCER　Now that the title has been added, it is time to select a printing company. Searching for a number of vendors can lead to a really satisfying one, but doing business with a new vendor is always risky. Therefore, I prefer to ask Intime, a printing house with successful transaction experience. To be precise, it is not a printing office equipped with printing facilities, but a printing agency that collaborates with several printing offices in Chungmuro and other areas. Also called a turnkey company, this kind of form always shines in busy times such as right now. (I am almost always busy.) Among many print agencies, Intime is *as the name suggests, a place with excellent time management.*⓫

⓫ Hyungjin Kim, Seongmin Choi, "Intime," *Graphic Design, 2005~2015, Seoul — 299 Vocabulary* (Seoul: Ilmin Cultural Foundation, Workroom Specter, 2020), 225.

⑪　　　제작처　　　제목까지 붙였으니 이제 인쇄 업체를 선정한다. 여러 업체를 찾다 보면 정말 만족스러운 곳을 만날 수도 있겠지만, 새로운 업체와 거래하는 것은 언제나 위험 부담을 전제한다. 따라서 성공적인 거래 경험이 있는 인쇄소인 인타임에 우선적으로 의뢰해 본다. 정확히 말하면 인쇄 설비를 갖춘 인쇄소가 아닌, 충무로 등지의 여러 인쇄소와 협업하는 인쇄 기획사다. 턴키 업체라고도 불리는 이 같은 형태는, 한 시가 바쁜 지금 같은 때에 빛을 발한다. (거의 항상 한시가 바쁘긴 하다.) 여러 인쇄 기획사 중에서도 인타임은 그 이름이 말해 주듯, 시간 관리가 뛰어난 곳❶이다.

❶ 김형진, 최성민, 「인타임」, 『그래픽 디자인, 2005~2015, 서울—299개 어휘』(서울: 일민문화재단, 작업실유령, 2020), 225.

In a similar vein, the title of "Architecture or Revolution" written by novelist Jidon Jung's short story is the French architect Le Corbusier's question about the greater value between architecture and revolution, but he has already chosen architecture. In response to this, the writer opened up the closed question once again through the novel.

비슷한 맥락에서 소설가 정지돈의 단편「건축이냐 혁명이냐」의 제목은 건축과 혁명 중 더 큰 가치를 묻는 프랑스 건축가 르 코르뷔지에의 물음이지만, 그는 이미 건축을 택한 바 있다. 이에 응답하여 작가는, 닫힌 물음을 소설을 통해 다시 한번 열어젖힌 것이다.

The representative proposition of the dilemma, "Which came first: the chicken or the egg?" is a question that seeks to logically reveal the causal relationship, and it is an unsolvable problem because there is no answer. These unsolved issues point out the futility of trying to determine order and superiority in the circulating cause and effect. So, "WHICH CAME FIRST."

딜레마의 대표격 명제인 '닭이 먼저냐, 달걀이 먼저냐'는 인과 관계를 논리적으로 밝히려는 물음이자, 답이 없기에 해결할 수 없는 문제이다. 이 미결 문제는 서로 순환하는 원인과 결과에서, 순서와 우열을 가리려고 하는 무용함을 지적한다. 그래서『뭐가 먼저냐』.

❿ Jiin Han, "Finishing — The Power to Live a Life that Desires Branding as a Weapon," *Branding Holding Hands* (Seoul: Hanibook, 2020), 193.

⑩ TITLE Roughly, the printing and production specifications have been decided, so I'm trying to ask the production company for a quote, but it's difficult to write an e-mail because the title of the book hasn't been decided on yet. Since this is a project with "form" and "content" as keywords, I came up with a few titles that include the two, but the dull sense given by abstract words only adds to the unnecessary aura. *If I put down a little bit of the compulsion to be at the forefront, the stress of being visible to survive* **❿** I can name the project with a moderate weight.

❿ 한지인,「마무리하며─브랜딩을 무기로 바라는 삶을 사는 힘」,
『손을 잡는 브랜딩』(서울: 한겨레출판, 2020), 193.

❿　　　제목　　　얼추 인쇄·제작 사양이 정해져서 제작처에 견적을
　　　　　　　　　문의하려는데, 아직 책 제목이 미정이라 메일 쓰기가
곤란하다. '형식'과 '내용'을 키워드로 하는 프로젝트이기에 이 둘을
포함하는 제목을 몇 가지 떠올려보았으나, 추상적인 단어가 주는
둔탁한 감각은 불필요한 아우라를 가중할 뿐이다. 선두에 나서야
한다는 강박, 눈에 띄어야 살아남는다는 스트레스만 조금 내려놓으면 ❿
프로젝트를 관통하는 적당한 무게의 제목을 명명할 수 있다.

❾ Ulises Carrión, "The New Art of Making Books," *The New Art of Making Books*, Translated by Kyungyong Lim, Hanbeom Lee, Seungeun Cha, (Seoul: Mediabus, 2017), 15.

It is common for the body text to be printed in black ink, but it can be disappointing if only black text appears on shiny gloss coated paper. To fully utilize the characteristics of gloss coated paper, metallic ink is used. This is because pearl or metallic ink is most effective when placed on glossy paper. Because of its principle, metallic ink is more difficult to implement on a monitor than on a print. Pantone 877 C, commonly called a silver spot color, belongs to the familiar side among metallic inks. The basics are only black, but some signatures are printed in two colors, black and silver, to *impose their own rules on communication.*❾

❾ 율리세스 카리온,
「책을 만드는 새로운 예술」,
『책을 만드는 새로운 예술』,
임경용, 이한범, 차승은 역,
(서울: 미디어버스, 2017), 15.

본문은 먹 1도로 인쇄하는 경우가 다반사지만, 반짝거리는 아트지에 검은 텍스트만 등장한다면 못내 아쉬울 수 있다. 아트지의 특성을 한껏 활용하고자 메탈릭 잉크를 사용한다. 펄이나 메탈릭 잉크는 광택지에 올려야 가장 효과적이기 때문이다. 메탈릭 잉크는 그 원리 때문에 인쇄물보다 모니터에서 구현하기가 더 힘들다. 흔히 은별색이라 불리는 팬톤 877 C는, 메탈릭 잉크 중에서도 친숙한 편에 속한다. 기본은 먹 1도로 하되 일부 대수는 먹과 은별색, 총 2도로 인쇄하여 의사소통에 자신만의 법칙들을 부과한다. ❾

⑨ INK COLORS

For the cover, sky-blue pastel spot color (Pantone 9461 C) is used to promote a natural connection with the bookshelf and end papers that the surface is in contact with. At the same time, it is also printed in black color to link with the inner pages of the book. The Cloud signature on which the figures will be raised is printed in only sky-blue spot color, inducing inevitable processing of the image. In addition to its texture, the violently changed image forms a dramatic contrast with the page where the text is located.

⑨　　　인쇄도수　　　표지는 그 표면이 맞닿아있는 책장, 그리고 면지와 자연스러운 연결을 도모하고자 하늘색의 파스텔 별색(팬톤 9461 C)을 사용한다. 동시에 책의 내지와도 링크하기 위해 먹까지 총 2도로 인쇄한다. 도판이 올라갈 클라우드 한 대수는 하늘색 별색 1도로 인쇄하여, 이미지의 불가피한 가공을 유도한다. 우악스럽게 변해버린 이미지는 그 질감에 더해, 텍스트가 위치한 페이지와 극적인 대비를 이룬다.

동해물과 백두

닭도록 하느님

天地玄黃宇宙

㉠(b)(3)④あ

ABcdEFgh 1

re
bra
cone
to que
subtract
and there
kinds of "pr
red, yellow ar
confusion of the

[...]

An opponent-hue fra
questions involving o
such as arise in the
1. colour psy
and physiolo
2. colo
use of

사회과학

불교

사회과학 일반

통계학

경제학,경영학,관
광경영,부동산,회
계학,조세,보험,취
업

자연과학

자연과학 일반

수학

기술과학

물리학

기술과학 일반

의학,약학,한의학,
보건학,간호학,다
이어트,요가

농학,수의학,수산
학,임업, 조경

공학,공업일
목공학,환경공
도시공학

예술

예술 일반

조각 및 조형예술

언어 일반

공예,장식미술

한국어

문학 일반

중국어

일본어 및 기타 아
시아어

한국문학

역사 일반

중국문학

일본문학 및 기타
아시아문학

아시아

유럽

아프리카

출판사 신고확인증

신고번호　제 2022-000080 호

명칭 및 소재지	명칭	프레스 프레스
	소재지	서울특별시 은평구 연서로9길 20-5 301호 (구산동)
대표자	성명	정대봉
	주소	서울특별시 은평구 연서로9길 20-5 A동 301호 (구산동, 예원빌)

신고연월일　2022 년 11 월 16 일

「출판문화산업 진흥법」 제9조제4항 및 같은 법 시행규칙 제4조제1항에 따라 위와 같이 출판사 신고를 마쳤음을 증명합니다

2022 년 11 월 16 일

서울특별시 은평구청장

Q in:sent

✏️ 편지쓰기

📥 받은편지함
☆ 별표편지함
🕐 다시 알림 항목
➤ **보낸편지함**
📄 임시보관함
⌄ 더보기

라벨　　　　　　　　＋

⌄ 더보기

단행본 『뭐가 먼저냐』 제작 문의

 DB Jeong <dbkor34@gmail.com>
김종민에게 ▾

안녕하세요, 이사님.
디자이너 정대봉입니다.

단행본 『뭐가 먼저냐』의 제작을 위한 견적 요청 드립니다.
자세한 제작 사양은 파일로 첨부하였습니다.
두 가지 사양 각각 견적 산출해주시면 감사하겠습니다.
그런데 혹시 12월 2일 이전에 납기가 가능할까요?

확인 후에 연락 주세요.
감사합니다.

정대봉 드림.
010-9753-4446

첨부파일 1개 · Gmail에서 스캔함 ⓘ

📄PDF 뭐가먼저냐_제작사양....

(↩ 답장)　(↪ 전달)

PANTONE 875 C

PANTONE 9441 C
PANTONE
PANTONE
PANTONE

PANTONE 876 C

PANTONE 9442 C
PANTONE Violet 0631
PANTONE Blue 0821
PANTONE Black 0961
PANTONE Extender
5.40
30.60
4.00
60.00

PANTONE 877 C
es Metallics

PANTONE 9461 C
PANTONE Blue 0821
PANTONE Black 0961
PANTONE Extender
27.00
3.00
70.00

PANTONE 9462 C
PANTONE Blue 0821
PANTONE Black 0961
PANTONE Extender
32.00
8.00

엑스프리아트 6.61mm

150g — 118㎛
112p ↺ +

118㎛ 0.94mm

16p ↺ +

㎛ 1.08mm

8p ↺ +

이사트 65mm
240
4p ↺ +

엑스프리아트 X-Pri Art 200g/㎡

엑스프리아트 X-Pri Art 180g/㎡

엑스프리아트 X-Pri Art 150g/㎡

매직터치
연하늘색
180g/㎡

매뉴얼지 (Manual)

스마트 (Smart)

E-Light

In line with the 16-page Cloud, the gloss coated paper is also folded in units of 16 pages. That is, the number of pages of gloss coated paper is 16, 32, 48, 64, 80, 96, 112, 128, … pages, which is a multiple of 16. Compare the various basis weights and count the number of cases that fit within the range. As a result, it was calculated that when 112 pages of 150 g/m² gloss coated paper were bound together, the thickness of 6.61 mm barely met the condition. *A rational form that does not betray context becomes a universal explanation of beauty.*[8] I would like to express my sincere gratitude to the creators of Paperman, the application of "Paper Usage Calculator for Book Production."

[8] Hezin O, "Writing About Writing 16 Pages," *Designed Matter* (Seoul: Goat, 2022), 60.

16페이지의 클라우드에 맞추어, 아트지 역시 16페이지 단위로 접지한다. 즉 아트지의 면수는 16의 배수인 16, 32, 48, 64, 80, 96, 112, 128, … 페이지가 될 수 있다. 다양한 평량을 대조하며 범위 내에 안착하는 경우의 수를 헤아려 본다. 그 결과, 150g/m² 평량의 아트지 112페이지를 묶었을 때 6.61mm의 두께가 되어 가까스로 조건을 충족함을 계산해 냈다. 맥락을 배반하지 않은 합리적인 형태는 아름다움에 대한 보편적인 설명❽이 된다. '책 제작을 위한 종이 사용량 계산기' 애플리케이션 페이퍼맨 제작자분께 심심한 감사를 전한다.

❽ 오혜진,「16페이지 글쓰기에 관해 글쓰기」,『디자인된 문제들』(서울: 고트, 2022), 60.

For the 181.6 × 221.6 mm, which is close to B5, it is still economical to print on B0 even considering paper loss. B5 can print up to 32 pages in total, 16 one-sided pages on short grain B0. At this time, if you print in half sheet (work and tumble), you only need to print one sheet instead of two sheets of CTP, so it is advantageous to put fewer pages in one signature. Therefore, for the Cloud on which the image is to be uploaded, only one signature is printed in half sheet, and the gloss coated paper on which the text is to be uploaded is used for the necessary thickness. When you do that, Cloud takes up a total of 16 pages and is 0.94 mm thick, so the gloss coated paper is allocated between 6.38 and 6.68 mm.

46배판에 가까운 판형인 181.6 × 221.6mm은 용지의 로스를 감안하더라도 46전지에 인쇄하는 것이 그래도 경제적이다. 46배판은 종목 결의 46전지에 단면 16페이지, 총 32페이지까지 인쇄 가능하다. 이때 같이걸이(일명 돈땡)로 인쇄하면 CTP 두 판 출력할 것을 한 판만 출력하면 되기에, 적은 페이지를 한 대수에 몰아넣기 유리하다. 따라서 이미지가 올라갈 클라우드는 같이걸이로 한 대수만 인쇄하고, 텍스트가 올라갈 아트지는 나머지 필요한 두께만큼 충당한다. 그렇게 했을 때 클라우드는 총 16페이지, 두께 0.94mm를 차지하므로 아트지는 6.38~6.68mm를 할당받게 된다.

In order for 20 books to fit into one shelf with an inner diameter of 190 mm, each book spine requires a width of 9.5 mm. Considering the free space and margin of error, a book thickness of 9 to 9.3 mm would be appropriate. The total thickness of 12 pages, including the cover and end papers that have been decided, is 1.72 mm, and 7.28 to 7.58 mm can be allocated to the inner pages.

내경 가로폭이 190mm인 책장 한 칸에 스무 권의 책이 알맞게 들어가기 위해서는, 한 권당 9.5mm의 책등 폭을 요한다. 여유 공간과 오차 범위를 고려한다면 9~9.3mm 정도의 책 두께가 적당하겠다. 결정을 완료한 표지와 면지, 총 12페이지의 두께는 1.72mm로 내지에 7.28~7.58mm를 할당할 수 있다.

⑧　NUMBER OF PAGES　There are a total of four types of paper to be used in the book (Insper M Rough, Insper Magic Touch, Hansol Paper Cloud, Hankuk Paper X-Pri art.), among them, Magic Touch, which corresponds to end papers, provides a single basis weight (180 g/m^2). The M Rough to be used for the cover is selected with the highest basis weight of 240 g/m^2 in order to firmly wrap the contents. One of the inner papers, Cloud, is set at 80 g/m^2, which is the higher bulkiness among the two options, 70 g/m^2 and 80 g/m^2. In the meantime, another inner paper, X-Pri art, as a classic in the coated paper world, provided 12 basis weights ranging from 80 g/m^2 to 360 g/m^2, taking away the determination I had barely had.

⑧ 면수 책에 사용할 종이는 총 네 종(인스퍼 M러프, 인스퍼 매직터치, 한솔제지 클라우드, 한국제지 엑스-프리아트)으로, 그중 면지에 해당하는 매직터치는 단일한 평량 (180g/m²)을 제공한다. 표지에 사용할 M러프는 내용을 견고하게 감싸기 위해, 최고 평량인 240g/m²으로 선택한다. 내지 용지 중 하나인 클라우드는 70g/m²과 80g/m², 두 가지 선택지 중 더 높은 벌키도의 80g/m²으로 정한다. 그러던 중 또 다른 내지 용지인 엑스프리아트가 도공지 계의 클래식답게 80g/m²부터 360g/m²까지 무려 열두 가지의 평량을 제공하여, 모처럼 있던 결단력을 앗아갔다.

The coated paper on which the text will be placed is gloss coated paper (a classic in the coated paper world), especially Hankuk Paper's X-Pri art. I thought it was meaningless to distinguish between paper makers for gloss coated paper, but I remember hearing a warning from the head of the printing company when I recently placed an order for production with paper from another paper maker. Since then, I respect the head's career and use Hankuk Paper's gloss coated paper without complaints.

텍스트가 올라갈 도공지는 (도공지 계의 클래식인) 아트지, 그중에서도 한국제지의 엑스프리아트로 한다. 아트지는 제지사를 구분하는 것이 무의미하다 생각했는데, 최근에 타 제지사의 용지로 제작을 발주했다가 인쇄소 기장님께 한 소리 들은 기억이 있다. 이후로는 기장님의 경력을 존중하여 군 소리 없이 한국제지 아트지를 애용한다.

It is crucial to choose bulky paper in order to even slightly lessen the load on the contents. Cloud of Hansol Paper boasts a high bulkiness (thickness compared to basis weight) that is twice as high as regular coated paper. It is one of the few high bulky papers made in Korea, and thanks to this, it is possible to produce books that are light in weight compared to their volume. Originally, High bluky paper has a very low whiteness, so it had a yellowish color close to gray. However, the Cloud realized a soft white color, maintaining the high bulky characteristics simultaneously. Most of all, it is excellent in price competitiveness, making it suitable for non-coated body text paper.

내용에 대한 부담을 조금이라도 줄이려면 벌키한 종이의 선택은 필수적이다. 한솔제지의 클라우드는 무려 아트지의 두 배에 달하는 벌키도를 자랑한다. 국내의 몇 안되는 하이 벌키 용지 중 하나로, 덕분에 부피에 비해 무게가 가벼운 책을 제작할 수 있다. 본래 하이 벌키 용지는 백색도가 매우 낮아 회색에 가까운 누런빛을 띠고 있는데, 클라우드는 하이 벌키한 특성은 그대로 유지하되 은은한 백색을 구현해냈다. 무엇보다 (모조지에 비할 바는 아니나) 가격 경쟁력이 우수하여 비도공 본문 용지로 제격이다.

It is frequently required to pack four-color images into one signature in low-budget publishing projects in order to lower manufacturing expenses. Here, texts and images are printed on different types of paper, suggesting that the content is different even as you turn the pages. Currently, the image is printed on coated paper, whereas the text is typically printed on uncoated paper. This is because off-white uncoated paper (like Simili) provides a comfortable and natural reading environment, and white gloss coated paper shows excellent print reproduction. Ignoring such conventional restrictions, text is printed on coated paper and images are printed on uncoated paper. The text printed on the almost blue and smooth gloss coated paper reminds me of the screen monitor, the origin of which it was written. Also, images printed on uncoated paper with a rough texture can evoke the presence of long-forgotten paper.

저예산 출판 프로젝트에서 제작비 절감을 위해, 종종 4도 인쇄 이미지를 한 대수에 몰아넣곤 한다. 여기에 텍스트와 이미지를 다른 종류의 종이에 인쇄하여, 페이지를 넘기는 감각으로도 내용의 성격 차이를 암시한다. 이때 대체로 텍스트는 비도공지에, 이미지는 도공지에 인쇄된다. 미색의 모조지는 편안하고 자연스러운 가독 환경을 제공하고, 백색의 아트지는 뛰어난 인쇄 재현을 선보이기 때문이다. 이 같은 상투적 제약을 무시하고 텍스트를 도공지에, 이미지를 비도공지에 인쇄한다. 하얗다 못해 푸르고 매끈한 아트지에 인쇄된 텍스트는, 그것이 작성된 기원인 스크린 모니터를 떠올린다. 그리고 거친 감촉의 비도공지에 인쇄된 이미지는, 까맣게 잊고 있던 종이의 존재감을 환기한다.

End papers physically connect the inner bundle of paper containing the contents and the cover that wraps it. (The end papers of wirelessly bound books are actually merely a customary form.) The function of the end sheets in mediating between form and substance is comparable to that of a bookcase in mediating between books and people. The paper most closely related to the color of the bookshelf, Insper Magic Touch light blue, is used as end papers. *The important thing here is the durability of the paper, and the existence of the end papers themselves has nothing to do with the contents of the book, but through the color of the papers … they can express a sense of unity with the book's content.*

7 *GRAPHIC* Editorial Department, "End Papers," *Paper is Beautiful* (Seoul: Propaganda, 2022), 66.

면지는 내용이 담긴 내지 묶음과 그것을 감싸는 표지를 물리적으로 연결한다. (무선 제본된 책에서 면지는 사실상 관습적 형식에 불과하다.) 내용과 형식을 이어주는 면지의 역할은 곧 책과 사람을 매개하는 책장의 역할과 닮은 구석이 있다. 책장의 색상과 가장 근접한 종이, 인스퍼 매직터치 연하늘색을 면지로 한다. 여기서 중요한 것은 종이의 내구성이며 면지의 존재 자체가 책 내용과는 관계가 없지만 종이 컬러를 통해 … 책 내용과의 일체감을 표현할 수 있다❼는 것이다.

❼
〈GRAPHIC〉 편집부, 「면지」, 『종이는 아름답다』 (서울: 프로파간다, 2022), 66.

⑦ PAPERS The texture of the paper surface can be
 actively used because post-processing,
such as laminating or UV coating, is completely disregarded.
The rough gloss paper serves the purpose perfectly because,
despite being coated, the texture feels as if it were almost
uncoated. Insper M Rough, which was famous under the name
of Montblanc in the past, is claiming to be the representative of
Rough Grosse from its name. Expecting the high whiteness, rich
texture, and vivid printing that the explanatory text puts forward,
M Rough Super White is selected as the cover paper.

⑦ 종이 라미네이팅이나 UV 코팅 등의 후가공을 일절
 생략하기 때문에, 오히려 종이 표면의 질감을
적극적으로 활용할 수 있다. 러프그로스 계열의 종이는 코팅 처리를 한
용지임에도, 거의 코팅하지 않은 것처럼 질감이 살아있어 그 의도에
완벽히 부합한다. 과거 몽블랑이라는 이름으로 유명세를 치렀던
인스퍼 M러프는 그 이름에서부터 러프그로스지의 대표를 자처하고
있다. 설명문에서 내세우는 높은 백색도, 풍부한 질감, 선명한 인쇄를
기대하며 M러프 슈퍼화이트 색상을 표지 용지로 정한다.

⑥ POST-PROCESSING

Since a significant portion of the budget was set aside for PUR binding, special post-processing for the cover doesn't seem necessary unless there is a specific purpose. In relation to the cover, I aim for *transparent container for content* ❻ and, with Beatrice Ward, an American typography historian and critic, I do so half-willingly, half-heartedly. (Wouldn't it be feasible to blind-stamp the cover, which is a similarly transparent, if the budget allows?) The glossy and matte coating that would have improved the cover's durability is likewise purposefully left off, and only this time, the paper's natural texture is completely exposed. This also serves to highlight the form, though.

❻ Michael Rock, "Fuck Content," *Multiple Signatures*, Translated by Seongmin Choi, Seulgi Choi, (Paju: Ahn Graphics, 2019), 88.

⑥　　후가공　　굳이 PUR로 제본하는 데 나름

❻ 마이클 록,「내용은 집어치워」,『멀티플 시그니처』, 최성민, 최슬기 역, (파주: 안그라픽스, 2019), 88.

큰 예산을 할애했기에, 별 목적이 있지 않는 이상 표지에 특별한 후가공은 불필요할듯싶다. 자의 반 타의 반으로 표지에서만큼은 미국의 타이포그래피 역사가 겸 비평가, 비어트리스 워드와 뜻을 함께 하여 내용을 위한 투명한 용기❻를 지향한다. (예산이 허락한다면 마찬가지로 투명한 공박 정도는 찍을 수 있지 않을까.) 표지 내구성 향상을 위한 유·무광 코팅도 과감히 생략하고, 이번만은 종이 본연의 질감을 온전히 노출하게 한다. 그런데 이는 결국 형식을 전면에 드러내는 것이기도 하다.

PUR binding, a form of wireless binding, is used in light of economic conditions. PUR binding is a technique for binding that uses polyurethane glue because of its outstanding elasticity and adhesive power. There is no concern about breaking the bound part since, unlike general binding glue, it retains rubber-like flexibility even after it hardens. Above all, its openability is good. It gives a feeling of satisfaction halfway between wireless binding and adhesive binding, and the production cost is almost exactly halfway between the two. Additionally, the joint between the spine and the cover is not glued, and OTA-Binding, in which only the cover and the end papers are partially glued, maximizes formal satisfaction. When opening the inner pages of a book that has been bound using OTA Binding, there is almost no resistance from the cover and it opens much more easily.

경제적인 여건을 십분 감안하여 무선 제본의 일종인 PUR 제본을 채택한다. PUR 제본은, 탄성과 접착력이 뛰어난 폴리 우레탄 성분의 풀로 제본하는 방식을 말한다. 일반 제본 풀과 달리 굳은 후에도 고무 같은 탄성을 유지하여 제본한 부분이 깨질 염려가 없고, 무엇보다 펼침성이 봐줄 만하다. 무선 제본과 사철 제본 중간 정도의 만족감을 주며, 제작 단가도 거의 정확히 둘의 중간 정도다. 나아가 책등과 표지의 접합부에는 풀을 칠하지 않고, 표지와 면지만을 일부 접착한 오타 바인딩으로 형식적 만족을 극대화한다. 오타 바인딩한 책은 내지를 펼칠 때 표지의 저항이 없다시피 하여, 한결 수월하게 펼쳐진다.

⑤ BOOKBINDING You can tell from experience that a
 book bound with adhesive binding
provides better openability than a book bound with wireless
binding, even if you are not a designer who works with printed
matter. The bulk of book designs use wireless binding, however,
which is likely due to the limi-
tations of production budget. ❺ Workroom Press, "About
Nothing is more pathetic than Simple Sbotage," *Simple
letters that curl into the page. Sabotage*, Translated by Hee-
Because of this, it is required beom Hong, (Seoul: Workroom
to specify the inside margin Press, 2018), 35–36.
of the page more marginally than the outside when binding with
wireless binding, but this *uncooperative attitude* ❺ is similar to
a particular format that imposes another formal constraint.

⑤　　　　제본　　　　사철로 제본한 책이 무선철로 제본한 책보다 우수한
　　　　　　　　　　　　　펼침성을 선사한다는 사실은, 굳이 인쇄물을 다루는
디자이너까지 아니더라도 경험에 근거하여
알 수 있다. 그럼에도 과반수의 단행본
디자인이 무선 제본의 형식을 띄는 이유는
아무래도 제작 예산의 한계 때문일 것이다.
페이지 안쪽으로 말려들어가는 글자만큼
비루한 형태는 없다. 때문에 무선철로 제본할
때엔 필히 페이지의 안쪽 여백을 바깥쪽보다 여유 있게 지정해야
하는데, 이 비협조적 태도❺는 특정한 형식이 또 다른 형식적 제약을
야기하는 꼴이다.

❺ 워크룸 프레스,
「생활 공작에 관해」,
『생활 공작』, 홍희범 역,
(서울: 워크룸 프레스,
2018), 35–36.

④ THE SIZE OF
THE BOOK

Considering the inner diameter of the bookshelf, the maximum possible book size is 227 × 277 mm. Makoto Naruke, CEO of the book review site Honz, stated in his book, "Organize the Bookshelf," that the *ideal condition of the bookshelf* is *a blank space of 20 percent.*❹ An individual's capacity for development is constrained by a bookshelf without margins. He convinced me to do the math, and I discovered that the height and depth needed margins of 45.4 mm and 55.4 mm, respectively, for 20% of the inner diameter. Therefore, 181.6 × 221.6 mm is the perfect book size for an excellent bookshelf. The book is about the same size as a B5 but has a significantly shorter vertical length, giving it a more refreshing feel.

❹ Makoto Naruke, "The "Space" of Bookshelves Left for Growth," *Organize the Bookshelf*, translated by Mihye Choi, (Seoul: Vision Korea, 2019), 18–19.

④ 판형 책장의 내경 사이즈를 고려할 때, 가능한 책의 최대 판형은 227 × 277mm이다. 서평 사이트 혼즈의 대표 나루케 마코토는 그의 저서『책장을 정리하다』에서 이상적인 책장의 조건은 20퍼센트의 여백❹이라 밝힌 바 있다.

여백 없는 책장은 개인의 성장 가능성을 제한한다는 것이다. 그에게 설득당하고 내경의 20퍼센트에 해당하는 여백을 계산해 보니, 높이와 깊이에 각각 45.4mm, 55.4mm의 여백이 필요했다. 따라서 이상적인 책장을 위한 이상적인 책의 판형은 181.6 × 221.6mm이다. 이 판형은 46배판과 유사하나 세로가 훨씬 짧아, 다소 새로운 느낌을 준다.

❹ 나루케 마코토, 「성장을 위해 남겨두는 책장의 '여유'」,『책장을 정리하다』, 최미혜 역, (서울: 비전코리아, 2019), 18–19.

Based on the dimensions of the bookshelf I had already ordered and the average thickness of books, it appeared that it could hold about 100 books. The bookshelf is divided into six sections, making it challenging to arrange a hundred books in an orderly fashion. (The number one hundred twenty is not as neat.) Fortunately, once I quickly contacted the manufacturer, the design could be adjusted, allowing the 20 books to be distributed equally across the five bookshelves. Also when you purchase offset printing for 100 volumes, it doesn't seem that embarrassing. Suddenly, I wonder why Raymond Queneau practiced 99 literary styles, not 100, in "Exercises in Style."

이미 주문한 책장의 사이즈를 보아하니, 평균적인 책 두께 기준으로 대강 백 권의 책이 들어갈만해 보였다. 다만 책장이 여섯 칸으로 나뉘어 있어 백 권의 책을 분배하기가 깔끔하지 못했다. (백이십 권의 숫자는 더 깔끔하지 못하다.) 곧바로 업체에 연락을 취했더니 디자인 변경이 가능했고, 다행히 다섯 칸의 책장에 각 스무 권의 책을 공평히 안배할 수 있게 되었다. 백 권이면 오프셋 인쇄를 의뢰할 때 그리 민망할 것 같지도 않다. 문득 레몽 크노가 『문체 연습』에서 백 가지가 아닌, 아흔아홉 가지의 문체를 연습한 이유가 궁금해진다.

Fill the bookshelf with multiple copies of the same book. The form has the ability to dominate the content because of unique visuals that can only be seen in a warehouse. It seems *utterly impossible to think of form and content as separate.*❸ Books' endlessly recurrent patterns will undoubtedly pique interest in both the formal organization and content of the book.

❸ Ben Shahn, "The Shape of Content," *Artist's Study*, Translated by Eunjoo Jeong, (Seoul: UU, 2019), 118.

한 책장을 여러 권의 같은 책으로 가득 채운다. 마치 물류창고에서나 볼 수 있을 법한 비주얼은, 형식에 내용을 압도하는 힘을 부여한다. 형식을 내용과 별개의 것으로 생각하기란 도무지 불가능❸해 보이지만, 무수히 반복되는 책등의 패턴은 그 책의 내용만큼이나, 형식적 구조에 분명 궁금증을 유발할 것이다.

❸ 벤샨, 「내용의 형상」, 『예술가의 공부』, 정은주 역, (서울: 유유, 2019), 118.

③ NUMBER OF COPIES It would be awkward to have a bookshelf with only one book on it, so there must be a pretext for having one. The book-cases are stacked with colored books of all sizes not just at home but also in bookstores. The information is surrounded by each new form, and it eventually takes on the structure of the bookcase.

③　　　제작부수　　　책장을 구비해놓고 고작 한 권의 책을 꽂아놓는
　　　　　　　　　　　것은 퍽 어색하기에, 책장의 명색을 갖출 필요가
있다. 가정집은 물론, 서점에서도 책장은 형형색색, 다양한 크기의
책으로 빈틈없이 채워져 있다. 각기 다른 형식이 내용을 감싸고 있는데,
그것을 또 한 번 책장이 감싸는 구조가 된다.

On the other hand, how about a bookshelf with one tier? Except for cases designed for decoration purposes, like TV cabinets, it is not a particularly popular shape. Since the bookshelf has a charm of filling up wall space in the past and using this as a clue, it is planned to place a single-tier bookshelf that is long horizontally and short vertically in the exhibition hall. Although it is not the most effective use of the available space, the large wall that surrounds the bookshelf gives the viewer a feeling of leisure and encourages them to reach down and take a book out, which creates the opportunity to consciously engage with the book's content. Regarding the bookshelf's color, sky blue, which is moderately connected to the white pages and the white exhibition hall, looks alright. Coincidentally, the final pre-order for a furniture brand this year was being received.

반면 1단짜리 책장은 어떤가. TV장과 같이 인테리어 용도로 사용되는 경우를 제외하면 그리 일반적인 형태는 아니다. 책장은 자고로 벽을 가득 채우는 멋이 있으니까. 이를 단서 삼아 가로로는 길고, 세로로는 짧은 1단 책장을 전시장에 비치할 계획을 세운다. 공간을 효율적으로 활용하는 방법은 아니나, 책장 위로 펼쳐진 광활한 벽면은 관람자에게 여유를 주고, 몸을 숙여 책을 꺼내는 행위를 유도함으로써 책의 내용으로 진입하기 위한 의식적 행위를 설정한다. 책장의 색상으로는 흰색의 페이지, 흰색의 전시장과 적당히 연결되고, 또 적당히 구분되는 하늘색이 무난해 보인다. 마침 한 가구 브랜드에서 올해 마지막 프리 오더를 받고 있었다.

② A BOOKCASE Although there are many different materials that can be used to make bookshelves, there are not many shapes that can come to mind. Most of the time, you'll visualize yourself deftly removing a book from a bookshelf that is eye-level with adults. From the bottom to the top of the multi-level bookshelf, books are tightly packed. A common environment where books and people or books and shelves are related is referred to as *a postponed place, where the future does not exist.*❷

❷ Jidon Jung, "Do Not Stay Anywhere, Heading Nowhere," *For You but Not Yours* (Paju: Munhakdongne, 2021), 90.

②　　　책장　　　책장이라 하면, 그 소재는 다양하나 떠올릴 수 있는
형태는 그리 많지 않다. 대개 성인 눈높이의 책장에서
우아하게 책을 꺼내는 모습을 상상할 것이다. 다단으로 구성된 책장의
바닥단에서부터 꼭대기단까지 빼곡하게 책이 꽂혀있다. 미래가
존재하지 않는 유예된 공간❷은 책과 책장이 관계하는, 혹은 책과
사람이 관계하는 예사로운 풍경이다.

❷ 정지돈, 「어디에도 머물지 않고 어디로도 향하지
않으며」, 『당신을 위한 것이나 당신의 것은 아닌』
(파주: 문학동네, 2021), 90.

Books that are being displayed are typically set on a white pedestal. Comfortable appreciation is purposefully hampered in the glittering exhibition hall by the majestic figure of the pure white pedestal. There is a good chance that a book will be put on the bookshelf when it leaves the exhibit hall. It's like being ready to be taken out at any time. The line separating daily life and an exhibition is broken by the simple act of bringing a bookshelf into the exhibition space. To *broaden the spectrum of possibilities in graphic design exhibitions while reducing the distance between designers' routine work and critical practice*, this can be *a certain strategy.*❶

❶ Sungmin Choi, Sulki Choi, "Design Exhibition and Designer," *Who's Afraid of White Cube* (Seoul: Workroom Specter, 2022), 166.

보통 전시를 위한 책은 흰색의 좌대 위에 놓이는 경우가 대부분이다. 눈 부신 전시장 속 새하얀 좌대의 위엄한 자태는 편안한 감상을 짐짓 방해하곤 한다. 전시장을 벗어나면 높은 확률로 책은 책장에 자리한다. 언제라도 꺼내어질 준비를 하고 있듯이 말이다. 책장을 전시장으로 들여오는 단순한 행위는 전시와 일상의 경계를 와해한다. 이는 그래픽 디자인 전시회에서 가능성의 스펙트럼을 넓히면서도 디자이너의 일상적 작업과 비평적 실천의 간극을 좁히기 위한 어떤 전략❶이 될 수 있다.

❶ 최성민, 최슬기, 「디자인 전시회와 디자이너」, 『누가 화이트 큐브를 두려워하랴』 (서울: 작업실유령, 2022), 166.

① EXHIBITION HALL The goal of this project is to turn the traditional publishing process order in reverse. Therefore, take into account the location of the book before creating it. I immediately picture the exhibition hall in my head because it is a project for an exhibition as well. (The door is yellow, but anyways) What format will the book take up residence in the exhibition area that stays close to the white cube?

① 전시장 이 프로젝트는 통상적 출판 과정의 역순을
지향한다. 따라서 책을 제작하기에 앞서, 책이
위치할 공간을 먼저 고려한다. 전시를 위한 프로젝트이기도 한 만큼,
우선 전시장의 공간을 머릿속에 떠올려본다. (문은 노랗지만) 화이트
큐브를 크게 벗어나지 않는 전시 공간에 책이 어떤 형태로 위치할까.

Mediabus, Amsterdam: Roma Publications, 2016.

⑭ National Museum of Modern and Contemporary Art, Korea. *National Museum of Modern and Contemporary Art, Korea Publication Guidelines*. Seoul: National Museum of Modern and Contemporary Art, Korea, 2020.

⑮ Seongmin Choi. *Material: Language*. Seoul: Workroom Specter, 2020.

⑯ Michalis Pichler. *Publishing Publishing Manifestos*. Translated by Gyeongyong Lim. Seoul: Mediabus, 2019.

⑰ Eric Spiekerman. *Typography Essay*. Translated by Jooseong Kim, Yongshin Lee. Paju: Ahn Graphics, 2014.

⑱ Johanna Drucker. *Diagrammatic Writing*. Translated by Sulki Choi. Seoul: Workroom Specter, 2019.

⑲ Minjung Kim, Semi Park, Donghyeok Shin, Juli Yoon, Miji Lee, Gyeongju Choi, Siwon Hyeon, COM. *Porcelain Berry*. Seoul: Hwawon, 2022.

⑳ Editorial Department of Open Books. *Open Books Editing Manual* 2022. Paju: Open Books, 2022.

국립현대미술관, 2020.

⑮ 최성민.『재료: 언어』. 서울: 작업실유령, 2020.

⑯ 미할리스 피힐러.『출판선언문 출판하기』. 임경용 역. 서울: 미디어버스, 2019.

⑰ 에릭 슈피커만.『타이포그래피 에세이』. 김주성, 이용신 역. 파주: 안그라픽스, 2014.

⑱ 조해나 드러커.『다이어그램처럼 글쓰기』. 최슬기 역. 서울: 작업실유령, 2019.

⑲ 김민정, 박세미, 신동혁, 윤율리, 이미지, 최경주, 현시원, COM.『사포도』. 서울: 국립현대미술관, 2020.

⑳ 열린책들 편집부.『열린책들 편집 매뉴얼 2022』. 파주: 열린책들, 2022.

① Sungmin Choi, Sulki Choi. *Who's Afraid of White Cube*. Seoul:
 Workroom Specter, 2022.
② Jidon Jung. *For You but Not Yours*. Paju: Munhakdongne, 2021.
③ Ben Shahn. *Artist's Study*. Translated by Eunjoo Jeong. Seoul:
 UU, 2019.
④ Makoto Naruke. *Organize the Bookshelf*. translated by
 Mihye Choi. Seoul: Vision Korea, 2019.
⑤ Workroom Press. *Simple Sabotage*. Translated by Heebeom
 Hong. Seoul: Workroom Press, 2018.
⑥ Michael Rock. *Multiple Signatures*. Translated by Seongmin
 Choi, Seulgi Choi. Paju: Ahn Graphics, 2019.
⑦ *GRAPHIC* Editorial Department. *Paper is Beautiful*. Seoul:
 Propaganda, 2022.
⑧ Dongsin Kim, Uirae Kim, Lucky Park, Ina Shin, Hezin O, Gijun
 Lee, Jiwon Lee, Jihyeon Lee, Dongkyu Jeong, Jaewan
 Jeong. *Designed Matter*. Seoul: Goat, 2022.
⑨ Ulises Carrión, Guy Schraenen. *The New Art of Making
 Books*. Translated by Kyungyong Lim, Hanbeom Lee,
 Seungeun Cha. Seoul: Mediabus, 2017.
⑩ Jiin Han. *Branding Holding Hands*. Seoul: Hanibook, 2020.
⑪ Hyungjin Kim, Seongmin Choi. *Graphic Design, 2005~2015,
 Seoul — 299 Vocabulary*. Seoul: Ilmin Cultural
 Foundation, Workroom Specter, 2020.
⑫ Korean Society of Typography. *Letter Seed 15: Sangsoo An*.
 Paju: Ahn Graphics, 2017.
⑬ Kyungyong Lim, Sungmin Choi. *Roma 1-272*. Seoul:

① 최성민, 최슬기.『누가 화이트 큐브를 두려워하랴』. 서울:
　　작업실유령, 2022.
② 정지돈.『당신을 위한 것이나 당신의 것은 아닌』. 파주: 문학동네,
　　2021.
③ 벤 샨.『예술가의 공부』. 정은주 역. 서울: 유유, 2019.
④ 나루케 마코토.『책장을 정리하다』. 최미혜 역. 서울: 비전코리아,
　　2019.
⑤ 워크룸 프레스.『생활 공작』. 홍희범 역. 서울: 워크룸 프레스, 2018.
⑥ 마이클 록.『멀티플 시그니처』. 최성민, 최슬기 역. 파주: 안그라픽스,
　　2019.
⑦ 〈GRAPHIC〉 편집부.『종이는 아름답다』. 서울: 프로파간다, 2022.
⑧ 김동신, 김의래, 박럭키, 신인아, 오혜진, 이기준, 이지원, 이지현,
　　정동규, 정재완.『디자인된 문제들』. 서울: 고트, 2022.
⑨ 기 스크라에넨, 율리세스 카리온.『책을 만드는 새로운 예술』.
　　임경용, 이한범, 차승은 역. 서울: 미디어버스, 2017.
⑩ 한지인.『손을 잡는 브랜딩』. 서울: 한겨레출판, 2020.
⑪ 김형진, 최성민.『그래픽 디자인, 2005~2015, 서울—299개 어휘』.
　　서울: 일민문화재단, 작업실유령, 2020.
⑫ 한국타이포그라피학회.『글짜씨 15: 안상수』. 파주: 안그라픽스,
　　2017.
⑬ 임경용, 최성민.『Roma 1-272』. 서울: 미디어버스, 암스테르담:
　　로마 퍼블리케이션스, 2016.
⑭ 국립현대미술관.『국립현대미술관 출판 지침』. 서울:

정대봉
DAEBONG JEONG